PAINTING OUTDOORS

BARRON'S

Painting Outdoors

First English edition for the United States and Canada published in 2011
by Barron's Educational Series, Inc.
© Copyright 2010 by Parramón Ediciones, S.A.—World Rights.
Published by Parramón Ediciones, S.A., Barcelona, Spain.
Original title of the book in Spanish: *Pintando al aire libre*
Text: Gabriel Martín Roig
Exercises: Gabriel Martín, Óscar Sanchís
Photography: Estudi Nos & Soto, Gabriel Martín

All inquiries should be addressed to:
Barron's Educational Series, Inc.
250 Wireless Boulevard
Hauppauge, NY 11788
www.barronseduc.com

ISBN-13: 978-0-7641-6443-9
Library of Congress Control Number 2010940737

Printed in China
9 8 7 6 5 4 3 2 1

PAINTING OUTDOORS

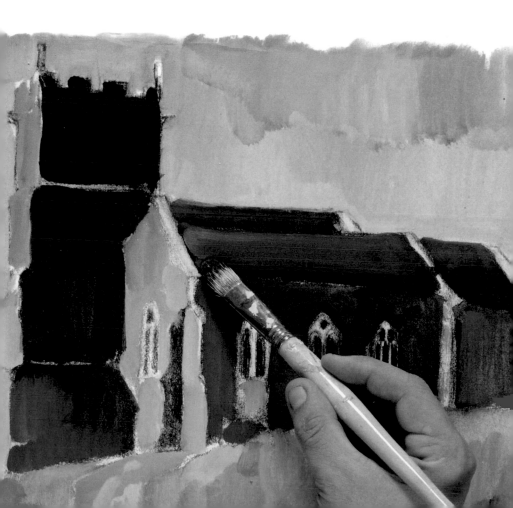

Contents

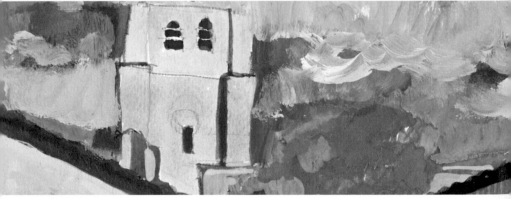

Introduction: The History of *Plein Air* Painting, 6

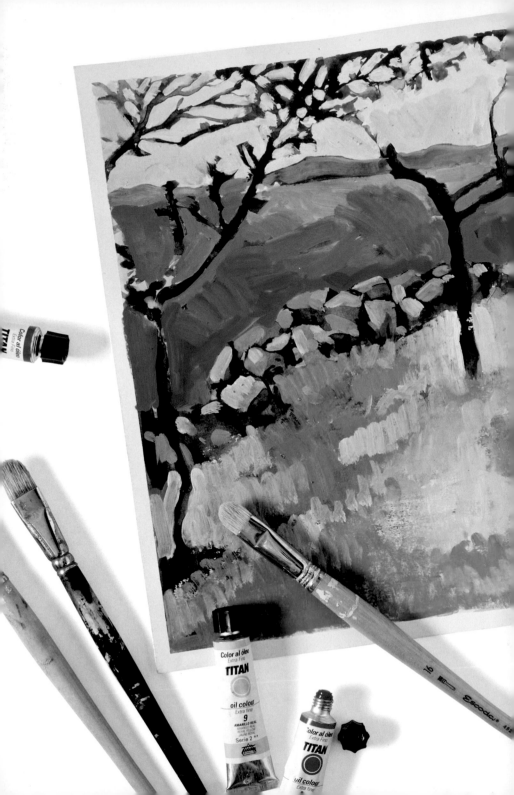

The History of *Plein Air* Painting

In the first half of the nineteenth century British painters became interested in painting *en plein air*, that is to say, painting outdoors, so they could be in direct contact with their actual subjects. They were mainly concerned with capturing the effects of light on nature, something that had not been done before then. This interest inspired them to paint cloud-covered landscapes using watercolors, to capture varying light conditions and the range of harmonious colors that could change from one moment to the next. The interpretation of the countryside done by several English painters, among them Turner and Constable, influenced their contemporaries to the point that they began to question ideas that were too rigid and academic, and they began to search for their inspiration directly in nature. Painters began to abandon the four walls of their studios and confront their subject in person. In doing so, landscape painting ceased to exist to merely provide a backdrop for dramatic battle and mythological scenes. The landscape itself became the protagonist in this new way of addressing the subject matter. The landscape genre was born.

A few years later, in the middle of the nineteenth century, a group of French artists began to meet in the town of Barbizon near Paris, to follow the ideas of the British landscapists, and the Barbizon School was founded. They specialized almost exclusively in the representation and interpretation of the landscape and they always painted studies of nature in person. They also developed new techniques of painting quickly in oils to capture the luminosity and atmosphere of the subject in the least possible amount of time. These same ideas would be adopted by the Impressionists, who showed a great interest in light and the chromatic variations in

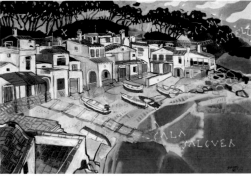

landscapes at different hours of the day and in different seasons.

Since that time, many artists have preferred to paint outdoors rather than staying trapped in their studios using cold photographs as models—especially when the weather provides an added bonus. *Plein air* presents some difficulties: one must be able to recognize and capture the subtleties of light, deal with temperamental weather, and try to ignore the curious passersby. But these minor problems are all worth it. Being in direct contact with nature offers the opportunity to truly connect with your subject, not only by observing first-hand its color, form, and texture, but also thanks to the vivid sounds and smells of the great outdoors which are sure to inspire.

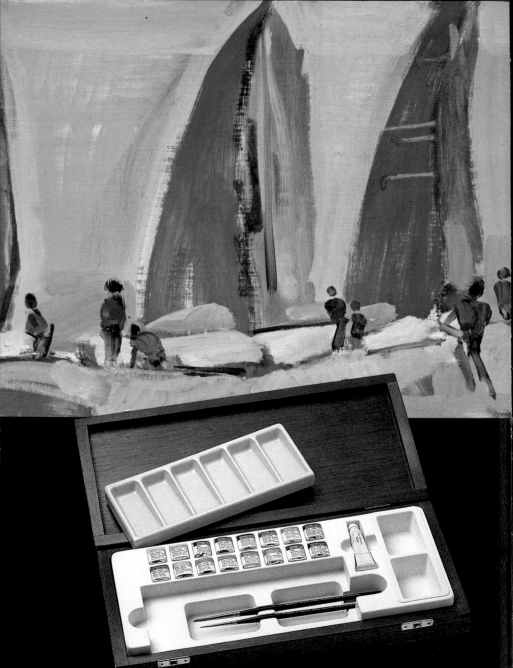

Materials and First Steps

When painting outdoors, the artist should have field equipment that differs slightly from that used in the studio. The components are manageable and easy to transport since the inconveniences of working this way are of a practical nature. You need to find a comfortable way of carrying your materials, and you will also want to carry some items to protect yourself in changeable or unpleasant weather.

Besides considering the best materials, it is also important to learn to plan the various stages of creating the painting so that you can work as quickly as possible. When painting *en plein air*, you must finish the work in a single session. Therefore, the outdoor painter must become very skilled at sketching quickly, painting in broad strokes, and at working over layers of still-wet paint.

The Necessary Tools

When packing your outdoor equipment you must not forget any tool, material, or accessory since none will be available in the field. In this chapter we will review the most indispensible tools for painting outdoors. Everything that you need should fit compactly into a small backpack or paint box. Try to avoid including anything that is not absolutely essential.

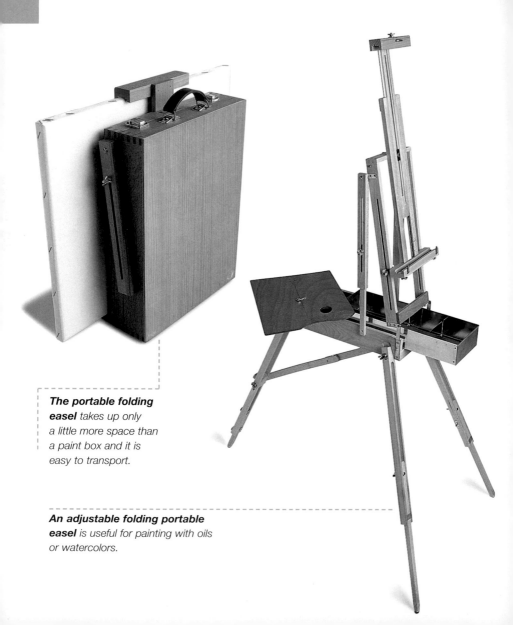

The portable folding easel takes up only a little more space than a paint box and it is easy to transport.

An adjustable folding portable easel is useful for painting with oils or watercolors.

Folding Easel with Box

Easels used for painting outdoors generally fold. They have a tripod shape, and the legs can be adjusted and fixed to the ground with metal tips that are inserted at the ends. If you can handle carrying a little more weight, the best option is an easel with a box, which has compartments for storing brushes, paint, charcoal, and other small items. The upper part can be easily tilted, and the box serves as a table or support for the palette. When folded up, it becomes a small briefcase that can be carried comfortably.

Canvases and Boards

Canvases for painting outdoors should be no larger than 20 inches (50 cm) on one side. If you wish to make several paintings in a single session plan to take three or four canvas boards. Paper made for oil painting is even lighter to carry. It simulates the texture and surface of a canvas and attaches to a rigid board with adhesive tape.

Canvas boards of different formats for painting oils.

When painting outdoors keep the mess to a minimum. Palettes with disposable sheets eliminate cleanup. They look much like a sketchpad, and have layered waxed paper sheets for single use. In the field, brushes should be simply wet with water or turpentine, depending on whether you are painting with watercolors or oils. Once home you can wash them thoroughly with soap and water so they will be in perfect condition for the next session.

Comfort Is Key

If you plan to set up for a long while in one spot, it is wise to seek out the best possible location and take some precautionary steps for working in comfort. These recommendations and accessories will make your outdoor painting session as relaxing as possible.

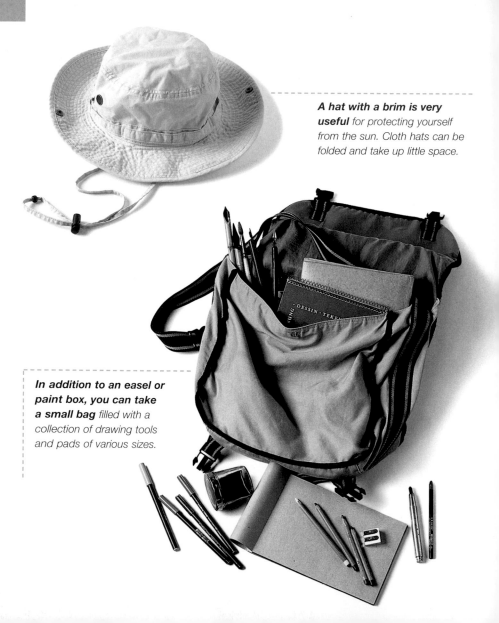

A hat with a brim is very useful for protecting yourself from the sun. Cloth hats can be folded and take up little space.

In addition to an easel or paint box, you can take a small bag filled with a collection of drawing tools and pads of various sizes.

In Summer

It is a good idea to wear a wide-brimmed hat to avoid the sun's harsh rays. An umbrella can also be useful. However, if you are out painting on a sunny day, the best protection is to set yourself up in a well-shaded area. When the heat is intense, be sure to bring plenty of water, sunscreen, and even insect repellant.

In Winter

Cold and rain can ruin your outing. Be sure to dress properly in warm, waterproof jackets and footwear. If you will be staying put for a long while protect your hands with fingerless gloves. If the weather looks iffy keep a raincoat handy to avoid unpleasant surprises during your country walk.

It is worth taking a small folding stool *that is easy to carry. Folding stools without backrests are very light and comfortable. There are also models that convert into a walking stick when folded, and they are quite comfortable too.*

A raincoat, which takes up such little space when it is folded, will serve you well during inclement weather.

Choosing a Subject

It is not necessary to look in the most picturesque places or to take a trip to a tropical paradise to find brightly lit subjects with lively colors. Some of the most memorable paintings are based on simple scenes found near home.

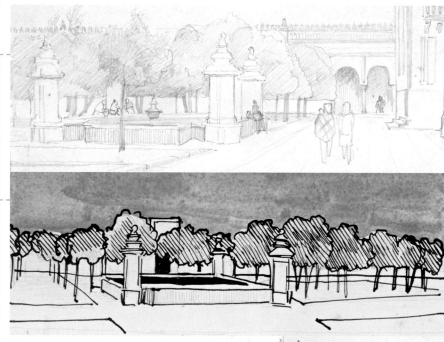

You should start in areas that you know—for example, a regular summer vacation spot—and discover all that these surroundings awaken in you. The street you live on, a nearby park, a familiar patio are all good choices. Your first steps should be simple drawings in pencil, ink, or washes.

Reduced Angle of Vision

Don't be too ambitious when choosing the subject. The small surface area of the canvas or paper allows you to capture only a little of what you see, so you should avoid large panoramas, views of cities, or landscapes that are too deep. It may be necessary to reduce the angle of vision and to focus on the foreground and middle ground so that the painting only depicts a portion of what is in front of you.

Using a Viewer

When painting outdoors a viewer can be very useful, since it helps you focus on isolated parts of the scenery. Close one eye and look through the viewer while moving it forward and backward until the subject is properly framed. Making a viewer is easy; all you need is a piece of black cardboard with a window cut in it.

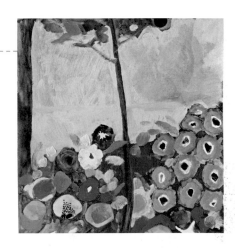

Once the subject is selected, the next step is identifying what is interesting to you and evaluating what can be modified or changed to make it even more attractive. Do not aim to make a photographic copy of the model, but rather try to represent it in a very personal way, as was done in this detail of a garden.

A viewer allows you to frame some details when the field of vision is very wide.

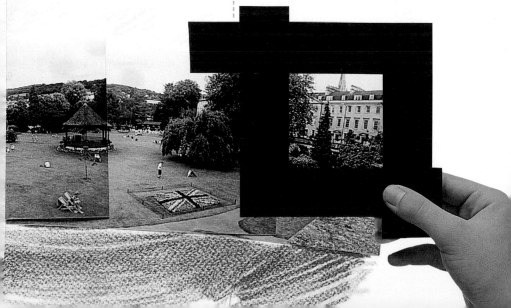

The Preliminary Sketch

In *plein air* painting, one should not spend too much time on the sketch. The idea is to only roughly capture the essence of the subject, keeping open the possibility of a new interpretation of the subject once colors are painted over it.

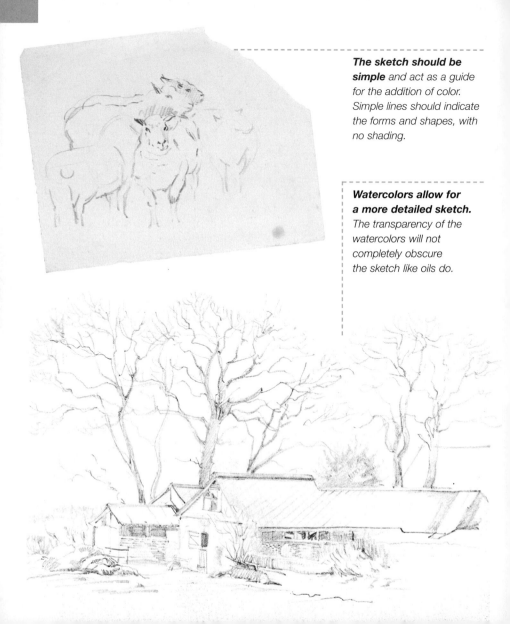

The sketch should be simple and act as a guide for the addition of color. Simple lines should indicate the forms and shapes, with no shading.

Watercolors allow for a more detailed sketch. The transparency of the watercolors will not completely obscure the sketch like oils do.

The Sketch as Guide

When painting with oils the preliminary sketch can be done in charcoal or even directly with diluted paint. This initial sketch is simply a guide and not a rigid map; the work should follow its own path as the painting evolves. Do not attempt to follow the charcoal lines when applying the paint even if this means deviating from your original plans.

The Watercolor Sketch

If you are working in this medium there are two options. You can choose to do a rough sketch with a graphite pencil, outlining only the most important shapes. The rest of the details can be later added with paint. However, if you intend to create a very detailed painting in a realistic style, you might choose to prepare a more elaborate and detailed preliminary drawing.

With oils, the preliminary sketch should be very simple. It can be done in pencil, charcoal, or even with a brush and diluted paint.

The speed required for plein air painting sometimes results in eliminating the preliminary sketch. Some artists use areas of paint as a synthesized sketch to suggest planes, shapes, and the major contrasts, especially when the subject is very simple. This technique can be used with both oils and watercolors.

Considering Composition

For good composition, a limited number of elements must be clearly differentiated in their tonality, shape, and size. In addition, composition should fulfill two fundamental objectives: achieving visual balance and awakening the viewer's interest. These goals can be achieved by applying the specific compositional techniques outlined here.

Include contrasting shapes in the foreground so the subject will be more interesting.

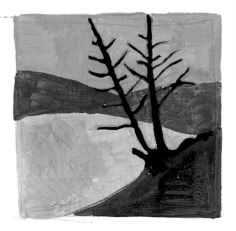

All paintings should have rhythm. This is achieved by introducing lines and brushstrokes that direct the viewer's eyes through the different planes in the picture. Including elements such as buildings, roads, fences, and rivers is very useful for this purpose.

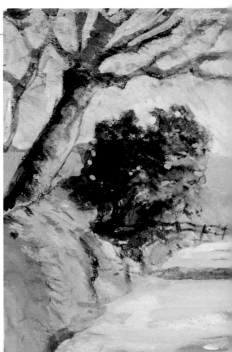

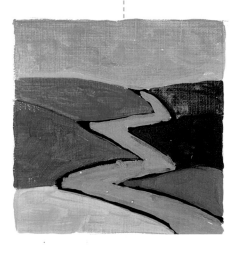

Avoid the Visual Center

Try to avoid symmetry; when all the interesting elements of the painting appear in the center of the canvas, the painting becomes too symmetrical and, therefore, boring. The main subject should be moved toward one side or the other to create greater visual interest.

Visual Obstacles

A wide panorama with few visual obstacles can become a boring painting. It is better to choose subjects that have elements that stand out in the foreground and middle ground. Once the framing has been decided, you can emphasize or suppress each one of these elements.

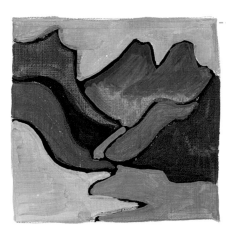

Modifying or exaggerating the curves that form shapes is another compositional technique that will increase interest in the painting. Here, the outlines of the mountains appear excessively rounded and very wavy, resulting in a very dynamic composition.

A Few Quick Brushstrokes

Plein air painting attempts to record a moment in time, capture the temporality, the fleeting appearance of a model in specific environmental conditions. Besides the subject, the important thing to record is what the artist perceives in an instant, and he or she should express it in a few brushstrokes that reveal the quality of the light and atmosphere.

Use a lot of paint, *and try to employ economical solutions when representing a scene.*

The application should be quick and instantaneous, *and built up with a few superimposed brushstrokes.*

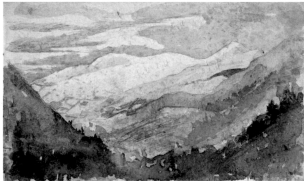

Add colors next to each other *so that they blend together.*

This spontaneity can be achieved with small format watercolors, *mixing the colors wet on wet.*

Cultivate a Style

Trying to capture just one moment and no other, as well as depict the model with specific light and weather conditions, will affect the formal characteristics of the painting, in particular, the type of brushstroke, which should be varied, vigorous, and personal. You must cultivate a style that allows maximum spontaneity and incorporates a very loose brushstroke. Distance yourself from details and anecdotes because they affect the freshness of the work, as well as unnecessarily prolong the time it takes to complete it.

A Broad Painting

It is best to work with a lot of paint and without hesitation so that your first impression is not lost, even though the first hits of color may seem sloppy. If you don't like the result, start again. Don't be timid; accept the risk of disappointment and of making mistakes. Don't be a perfectionist or waste time trying to fix a painting that just doesn't work.

Outdoor paintings should be small and quickly made. They are known for their simplicity and seemingly nervous brushstroke.

The Diluted Brushstroke

The subject for this first exercise is an architectural scene from a small mountain village.

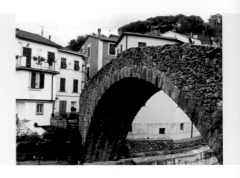

DILUTED PAINT

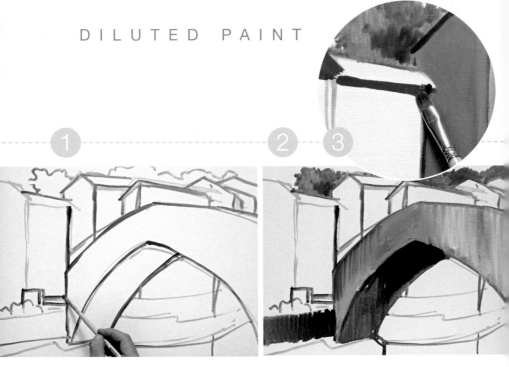

1. *It is not necessary to make a drawing with charcoal; just use some paint diluted in turpentine to make a quick layout sketch.*

2. *The planes of the nearest elements are covered with very diluted gray, burnt umber, and green using a wide brush.*

3. *The roofs of the houses are defined with each color applied in a very flat style. Be careful to avoid dripping and running paint.*

When painting outdoors you must work very fast. Learn to capture the subject with wide brushstrokes of diluted oil paint to create a base for future layers. The process is simple: cover the main areas of color with diluted paint, ignoring any detail or texture that requires a more involved painting technique. The edges between the colors are controlled to keep them from coming into contact with each other and accidentally mixing.

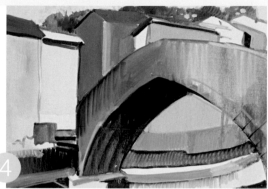

4. Each façade is covered with a single color, skipping the windows, doors, and balconies. The shapes of the trees are better defined when painting the sky.

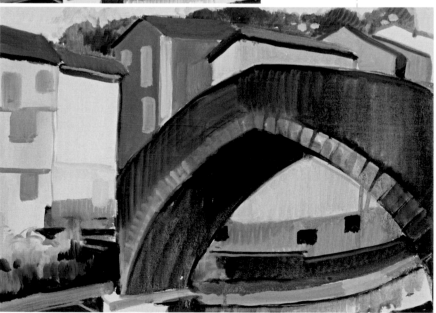

5. The windows, the foreground nearer vegetation, and the stones of the bridge are suggested with a few simple strokes. Then stop. The initial sketch is complete. From here on, the work should continue with thicker paint.

John Sell Cotman
(1782–1842)

Self-Portrait of John Sell Cotman

PLEN AIR PAINTING

Duncombe Park, *(1806)*
Cotman's works stand out for their extreme sensitivity and simplicity in the treatment of nature. First each zone is clearly delineated; then the different tones of each wash separate the planes of the image and gives it depth. The trees are painted as separate zones, with very flat colors, reserving small areas penetrated by the light of the sky. He worked with few overlays of color.

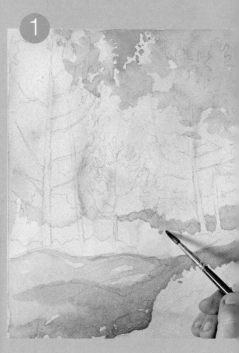

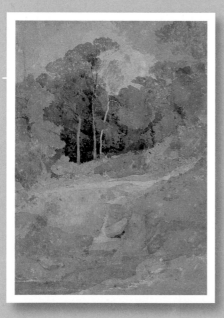

1. The tops of the trees are outlined with a graphite pencil and more detail is added to the shapes of the trunks. The paper is covered with an overall wash of ochre. When dry, new washes are overlaid on the sky, on the rocks in the lower part, and on the vegetation.

He was one of the most renowned painters of the Norwich School, a group of great *plein air* painters that became famous in England at the beginning of the nineteenth century. His watercolors shunned the baroque style and were known for their great simplicity. Created with more or less flat washes, his work was possibly influenced by Chinese painting that was making an appearance in Europe during those years.

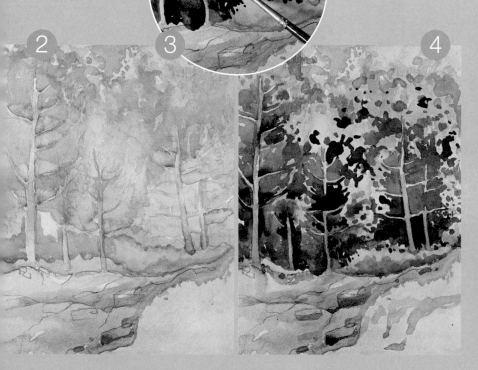

2. *The previous layer should be dry when a new wash of green is applied. Do not rush as you intensify the colors of the painting with each new addition of overlaid color.*

3. *The most intense contrasts of the trees are left for last. This layer of color should be very defined since it contributes to making the edges of the trees and the vegetation sharper.*

4. *When the previous washes are dry, the final touches are added to the rocks in the foreground. Despite the complexity of the subject it was treated simply with a great economy of color.*

The Importance of the Brushstroke

The first applications of paint on a canvas determine the final result of the work since they are the basis for all the brushstrokes to follow. They should be highly stylized simple notes of color. They are the first chromatic reference of the model, but given the importance of this first phase, it is a good idea to consider different ways of beginning a painting if you are working with oils.

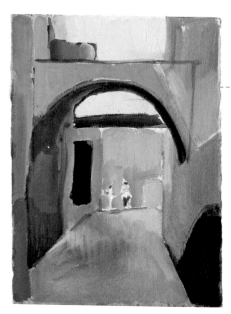

Each area of color is clearly differentiated, with little blending or gradation.

A convenient method is to simply cover each zone with an application of flat, uniform color, creating something much like a puzzle. This sets the maximum level of synthesis of the colors of the subject.

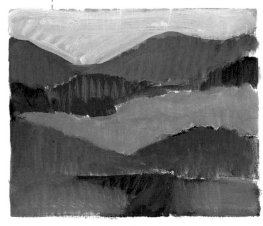

Using vertical diluted brushstrokes you can juxtapose each one of the bands of color.

Diluted Brushstrokes

The canvas is quickly covered with oil paint diluted with turpentine. You should work with colors that are more or less gray and muddy while avoiding runny paint. With this technique it is a good idea to work on a white or light colored background. Pay attention first to the largest areas and match them to colors similar to those of the real subject.

Cover the Canvas

Thanks to the thick, fluid paint spread with each brushstroke, the lines of the subject are distinguished and the main color contrasts are defined. The lines of the preliminary sketch almost completely disappear. Sometimes the first applications of color are somewhat darkened by the sketch's charcoal, but this is not cause for concern because the colors do not need to be precise at this stage.

Diluted paint, besides rapidly covering each area of color, affixes the charcoal from the preliminary sketch to the background.

Each new brushstroke offers a new tonal variation that breaks up the monotonous uniformity. These are not the final colors, but they create a good base.

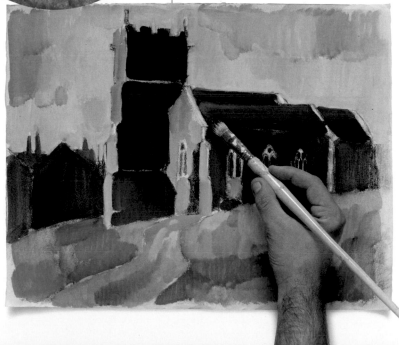

Preparing the Supports

When you decide to paint with oils you should have a selection of small canvases and panels prepared for painting outdoors. It is a good idea to take various formats to be ready for the different scenes you might encounter. The supports should be light and easy to carry. The best ones are canvas boards, small format canvases, and paper prepared for oil painting. They can be either white or previously colored with a coat of paint.

All artists should carry some prepared supports, dry and ready for painting.

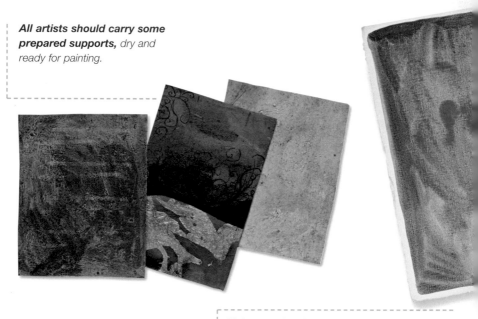

If the weather is warm you can use gesso to make textures before painting. Gesso dries quickly when it is left in the sun.

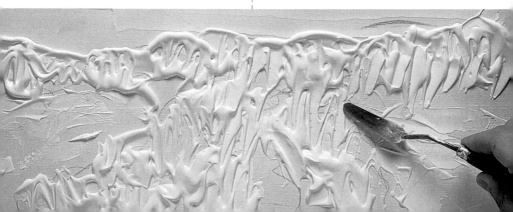

The Format of the Support

Avoid working with canvases that are too large; they can be awkward to carry and difficult to handle on windy days. Good supports are canvases or canvas boards that measure no larger than 16 × 20 inches (40 × 50 cm).

Prepared Surfaces

It is not necessary for the supports to be white or untouched. They can be prepared at home with different colored backgrounds. This will prevent the white fabric from reflecting too much light in the bright sun. To prepare a colored background you simply spread a coat of diluted paint. You might also choose to take paper or cardboard prepared with collage or textured surfaces. It is best to prepare these a week ahead to ensure that they will be completely dry.

One of the most common ways to apply a background is by using diluted paint. It is usually applied very thinned so it will dry faster.

Canvas carriers make it easy to transport freshly painted work. These are handles with clips that allow you to transport paintings face to face without the wet surfaces touching each other. You can also buy separating tacks, which are much more useful for cardboard or wood boards.

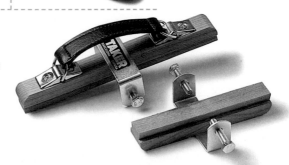

Painting an Oil Sketch

A wide, loose brushstroke is normally used when working outdoors. Colors are applied just as they are, straight from the tube, with no chiaroscuro. You must control the mixtures and the effects that can be achieved

The brushstroke will be better if it is striated, showing the marks of the bristles, and it should follow the direction of the texture of the object being represented.

Diluted paint is only used in the first phase of the work and is not appropriate for later phases.

Avoid painting with strokes of uniform color, which turn out bland and boring.

Continually apply small variations of color— this technique is more attractive and enriches the painting.

with oils to correctly express the form and texture of each element. Color is not the only important thing here; the way the paint is manipulated and how it is applied to the canvas also matters.

You must not blend the colors too much nor attempt perfect gradations.

The brushstrokes should be mixed in an irregular fashion without completely blending.

Do not worry about the white of the support showing. In fact, it can be a good thing when it frequently shows between the brushstrokes.

If a work ends up with too much paint, the excess can be removed by placing a sheet of newspaper on the area and lightly pressing with your hand.

Apparent Perspective

Here we are referring to the painter's perspective, which should be determined in a short amount of time without the help of rulers and T-squares. Your main objective is to represent an urban or rural scene in a coherent manner, well proportioned and with correct perspective. You might not be mathematically correct, but your interpretation should work and the viewer should not be able to perceive the small errors that the drawing will undoubtedly contain. This is why we call it apparent perspective.

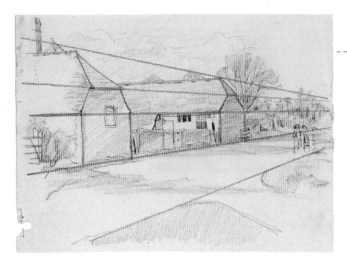

In a rural scene you must make sure the houses more or less align with the diagonal lines of perspective.

When the vanishing points are outside of the support, a good way to accurately draw lines of perspective is to make divisions in the vertical lines. For example, if you are drawing the corner of a building you can divide it into a number of segments. The diagonal lines are projected from the upper and lower parts. Then make the same number of divisions at the edge of the support. Finally, connect the corresponding points with straight lines drawn freehand.

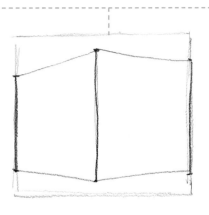

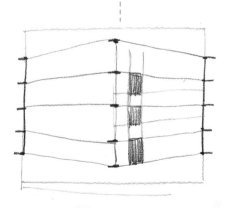

Tho Paintor's Perspective

Creating perspective is always a major obstacle for the amateur artist. It is important, though, to efficiently recreate an urban scene with a well-organized perspective. Apparent perspective uses several tricks to make representations successful. One of them is to work with one or two vanishing points located at each side of the paper, and extending all the diagonal lines from them to represent the space.

The Fan Effect

An expert painter usually draws buildings by eye without making too many precise calculations, since he is aiming for coherence. One golden rule should be followed: distribute all diagonal lines that extend towards the same point on the horizon in the shape of a fan. This method helps to determine the angles of doors and windows on a façade. To avoid complications, all of the vertical lines (corners, posts, doors, drainpipes, etc.) should be considered straight and parallel to each other.

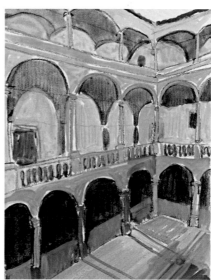

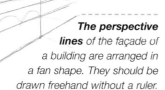

The perspective lines of the façade of a building are arranged in a fan shape. They should be drawn freehand without a ruler.

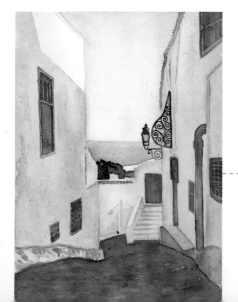

Guided by the background lines, *the façade is composed while keeping all the following perpendicular lines parallel. Paint (in this case, oil) is then applied. The resulting image is accurate.*

Study this watercolor painted according to the rules of apparent perspective. *It is not necessary for all the lines of perspective to coincide exactly at the same point, but they should be close to it.*

Pine Trees in Watercolor

This group of trees was chosen because they have interesting diagonals that create an interesting composition.

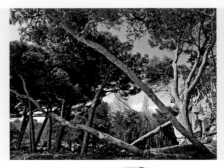

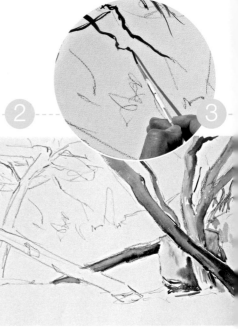

1

2

3

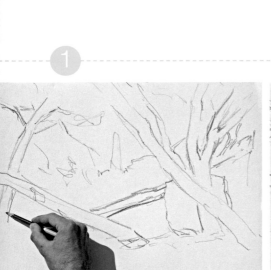

1. The sketch is made with a blue pastel pencil, which means the lines can be blended by simply rubbing with a finger. The sketch's lines will become part of the final composition since they will later mix with the watercolor washes.

2. The trunks are painted with a mixture of yellow ocher, raw sienna, and blue to create the diverse gray tones. The blue pastel is diluted in the washes and helps define the bluish shadows.

3. The complicated branches are executed with a smaller brush using linear strokes that begin at the trunk and then make a wavering line. When the pressure of the brush is reduced, the branch becomes progressively thinner.

4. The sky is created with a very transparent blue wash, and it is blended with the green of the more distant vegetation to give it an unfocused effect.

After a tranquil walk through the forest you have found a new subject to paint—a group of pine trees growing at different angles. In their shadow you prepare a sheet of watercolor paper on a rigid support.

You open the watercolor box and moisten the paint with a wet brush. To sketch the scene you choose a blue pastel pencil. But wait. Before drawing you should carefully observe your model for a while.

5. While the watercolor is still wet you can create incisions and scratches on the surface of the paper to suggest the texture of the grasses in the center of the painting.

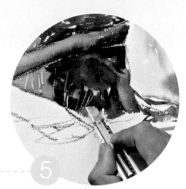

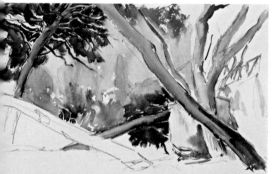

6. Óscar Sanchís created this painting in one hour. The foreground was made with green washes applied wet on wet. The trees required more meticulous work.

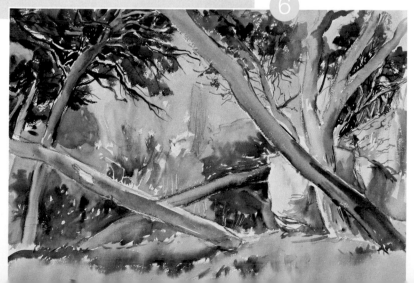

Theodore Robinson
(1852–1896)

*Robinson was an atypical impressionist
painter who spread this particular style
across the American continent.*

BLUISH SHADOWS

Capri, *(1890).*
*In this painting Robinson respects the
subject's structural and architectural
elements, that is, all of the planes of the
buildings, which are later filled with lively
brushstrokes. The façades are illuminated
with splashes of color, and the entire surface
of the painting seems to vibrate, animated
by the multitude of small brushstrokes. The
violet and blue shadows, very typical of
the Impressionists, contrast strongly with
the warmer colors of the sunlit façades.*

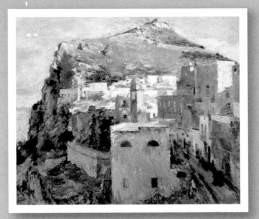

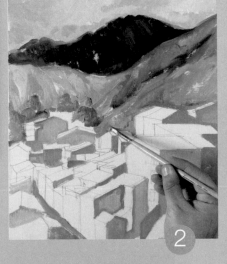

1. *The preliminary drawing, done in pencil,
helps put apparent perspective into practice.
The shaded façades of the buildings and the
sky are painted with blue and violet tones.*

He was one of the first American artists to become interested in the possibilities offered by the expressive and separated brushstrokes of the Impressionists. He was never considered a faithful follower of the movement; however, he did adopt the aesthetic of Claude Monet, with whom he lived in Giverny (France) for five years. He was a staunch practitioner of *plein air* painting, and he became especially interested in rural landscapes, which he painted in different weather conditions.

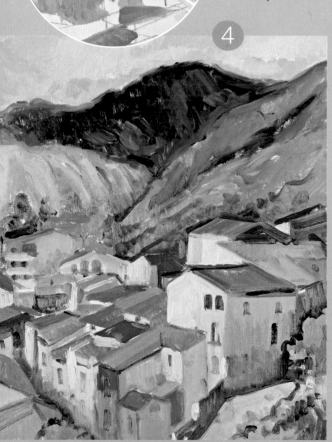

2. *The vegetation in the landscape is quickly painted with a combination of varying amounts of sap green, blue, cinnabar green, and yellow ocher. The brushstrokes are visible. The different green tones are just barely blended on the surface.*

3. *Now to illuminate the façades and rooftops that receive direct sunlight. This effect Is created by combining different varieties of orange, pink, and yellow tones. Barely diluted, thick, opaque paint is used here.*

4. *Finally, a few linear strokes of dark gray are applied under the eaves of the roofs and on the façades to suggest doors and windows. All these details should only be hinted at; do not attempt to be precise or detailed, but rather very suggestive.*

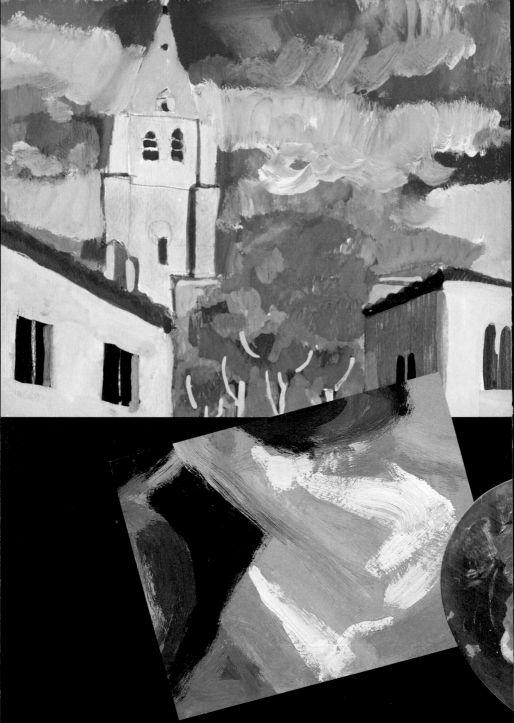

Synthesis and Quick Painting

Quick painting is a method born of *plein air* painting. It is characterized by the use of specific techniques that allow you to work faster than if you were to use a more methodical, academic process. Remember that we only set aside a single day to finish one *plein air* piece—or perhaps a few hours to complete a couple of smaller pieces. When you work with watercolors, the quick drying time and the small size of the medium allow you to finish any subject in a short time; however, when using oils, you will need to learn some strategies that are fast and effective, and that offer multiple options for painting outside.

Pretend It's a Sketch

Drawing using the concept of sketching allows, more than any other method, the chance to capture the shape and volume of the image that you wish to represent. The essence of a subject can be expressed with a few quick lines that reveal the quality of light and the principal contrasts. Sketches help us develop our visual perception more clearly, and the limited time imposed by a sketch forces us to capture just the fundamental details of the subject, leaving less important ones out.

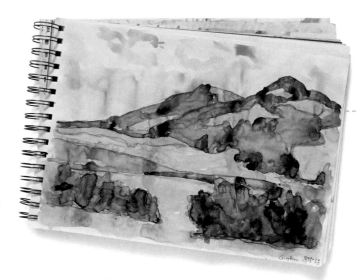

Realism is not the goal of a sketch. The synthetic impression of the subject is more important.

You may want to use two sheets of your sketchpad to create drawings in a landscape format.

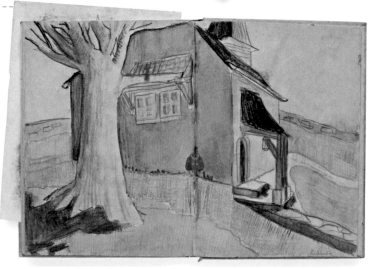

Learning from the Sketch

Outdoor painting can learn a lot from sketching. In both cases, pictures are created under a time constraint, and the finished product should capture instantaneous sensations and impressions of the subject. As in sketching, *plein air* painting should be quick and expedient; there is no time for perfectionism or corrections. If the painting doesn't turn out well, simply paint another one.

How to Speed Up

It's best to work in small formats (which also are handy for amateurs) to get the feel of things, loosen up, practice techniques, or experiment with brushstrokes. Because of the speed required, the outdoor artist should not stop to double-check or take measurements; decisions should be made mentally. This approach will result in a less exact product, but it will benefit by spontaneity and the artist will develop his or her visual skills.

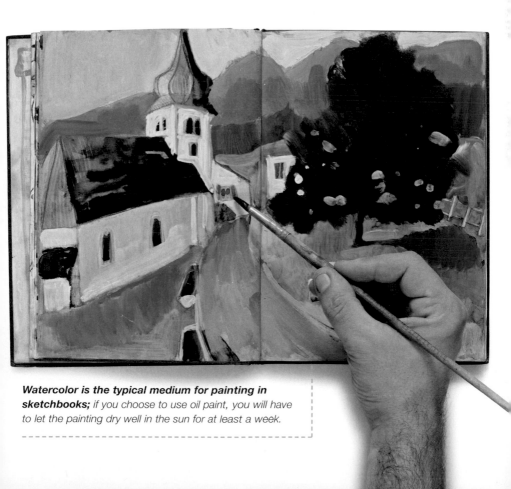

Watercolor is the typical medium for painting in sketchbooks; if you choose to use oil paint, you will have to let the painting dry well in the sun for at least a week.

A Beach in Watercolor

The chosen subject is a beach with a generous expanse of sand on the foreground.

THE ESSENTIAL FEATURES

1 **2**

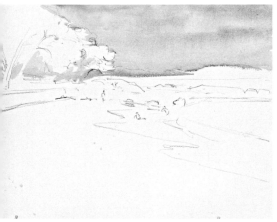

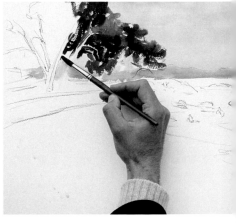

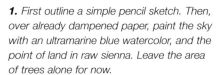

1. First outline a simple pencil sketch. Then, over already dampened paper, paint the sky with an ultramarine blue watercolor, and the point of land in raw sienna. Leave the area of trees alone for now.

2. Paint the crown of the trees with permanent sap green mixed with Payne's gray. These strokes should be dark, since you are trying to capture the strong contrast or silhouette effect produced by the sky. Leave small white spaces to show the light shining through.

We are now going to paint a beach scene as if we were making a sketch; that is to say, using only a few brushstrokes. Only the essential features are important, not the details. To apply the washes of watercolor in a quick and confident way, it is important to have a clear idea of what you wish to express, and to leave out the elements that do not contribute to your vision. Furthermore, you must stick to a limited range of colors to avoid complicated mixes that will hinder your spontaneity.

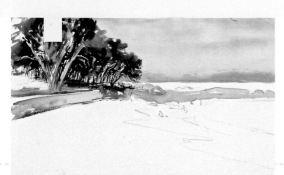

3. The tree trunks should be suggested with simple linear strokes, as you begin to work on the sand with a combination of different earth colors: ocher, raw sienna, and burnt umber.

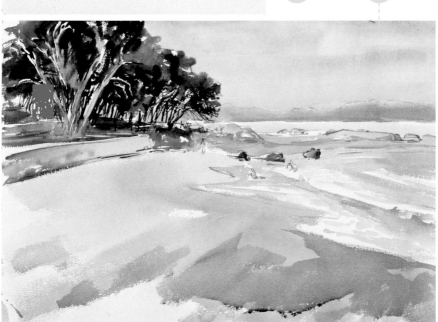

4. Finish painting the water using a green gray. Leave the foam on the waves unpainted, in white. The sand in the foreground receives an extremely simple treatment. Apply ocher shaded with touches of violet and then a large stroke of raw sienna in the lower part. (This exercise was created by Óscar Sanchís.)

THE SUBJECT

Learn to Synthesize

Before beginning to learn the process and techniques of painting quickly, try this simple exercise: sketch a landscape in a small format and in a short amount of time. This practice will improve your sketching and composition techniques, and will help you develop new ideas and make note of interesting subjects.

In five-minute sketches, we have synthesized the subject with just a few brushstrokes.

The colors are not exact (since it is necessary to mix them quickly), but the combinations show harmony and coherence.

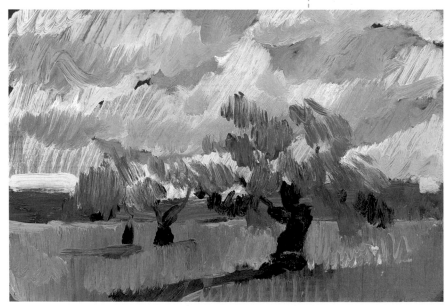

Only Five Minutes

For this exercise, choose small-format foundations such as paper prepared for painting with oils or a piece of cardboard. The idea is to limit the execution of your painting to five minutes. Place a watch somewhere visible so you do not exceed the allotted time. With so little time, you will want to mix your colors quickly and paint in a hurry. Paint three or four different subjects, which can be done by simply changing your position in front of any given landscape.

The Importance of the Study

Many artists prefer to create studies in a notebook or on loose pages, cardboard, or wood boards, instead of relying on photographs. In this way, they capture their personal impressions with few strokes of paint, to prepare for a later work of greater depth. Painting on colored cardboard, saves even more time.

The paint should be very diluted or creamy, so that the brush glides quickly over the surface.

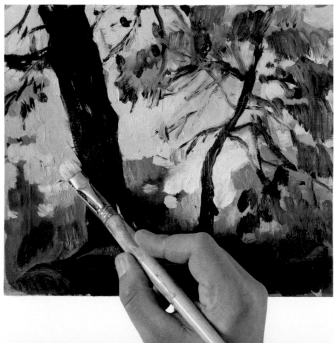

The obvious brushstroke marks and the unfinished areas of the canvas make this sketch fresh and expressive.

Painting Quickly

Quick painting is the most appropriate method when working outdoors. It is characterized by speed and the mixing of colors directly on the support. It does not permit the artist to work over several sessions; but rather requires that the piece is completed in a single day, or even in just a few hours.

Paint is mixed on the support, working quickly.

The idea is to roughly capture the subject, with strong, wide brushstrokes and barely mixed colors.

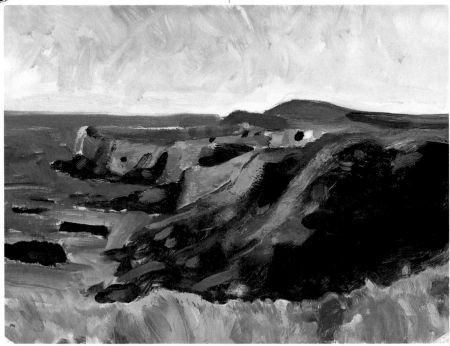

Thick Paint

Quick painting takes advantage of the natural consistency of oils, which are thick and creamy. This consistency permits quite a lot of paint to accumulate on the surface of the support. Though this might seem like a drawback, it is actually an advantage, since most of the color mixing is done directly on the canvas rather than on a palette. The brush marks remain on the relatively thick layers of paint. These traces of dragging and strokes enhance the beauty of the finished product.

Participate in Competitions

On weekends, mainly during fair-weather months, many European towns hold contests for painting outdoors, sometimes called *plein air* competitions. Participating in one of these is a great way to put amateurs to the test and see where they stand in comparison to the other artists. Such contests are held less often in the United States, but you may consider organizing one with fellow painters.

Don't seek out intricate subjects, since quickly painted pieces show few details.

When painting the sea you rarely mix colors on a palette; the blending is done directly on the support, although it may seem crude.

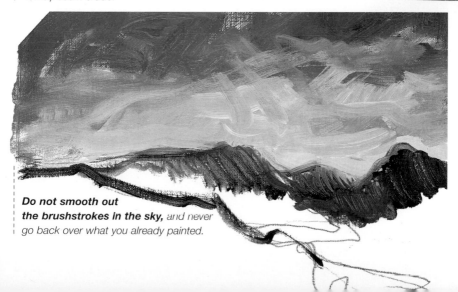

Do not smooth out the brushstrokes in the sky, and never go back over what you already painted.

Applying Color With the *Alla Prima* Technique

In conventional painting, colors are first mixed on a palette in order to paint with one uniform color on the canvas. With a technique like *alla prima* (literally meaning "at once"), paints are rarely mixed on the palette, but instead are mixed directly on the canvas. *Alla prima* painting is therefore also known as "direct painting."

A brushstroke with two colors *previously mixed on a palette.*

The same two colors mixed *directly on the support.*

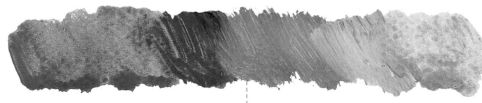

A conventional gradation *applied wet on wet made with blue and yellow.*

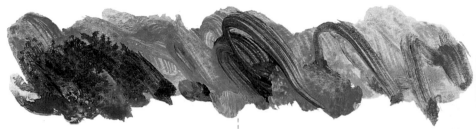

The same gradation using the **alla prima** ***technique*** *is less obvious and incorporates more brushstrokes; it shows more energy.*

Direct Mixing on a Support

In *alla prima* painting the modeling is done by blending colors, meaning that you go from one tone to another by mixing them on the canvas with a few brushstrokes. This is done directly on the canvas with thick oil paint and loose brushstrokes that are clearly visible, allowing the colors to blend in an irregular way. They are together, and yet separate within the same brushstroke.

Wet-on-Wet Painting

When painting over wet applications you can apply light colors over dark ones, but you must proceed carefully. There are three basic methods for this. The first is painting with the tip of the brush on a layer of still-wet paint. In this case, the brushstroke will be striated because the bristles of the brush lightly drag the underlying paint. A second approach is to brush repeatedly so that the light color absorbs the darker color underneath to create a new one. Finally, you can angle the brush to paint with the side instead of the tip; this way the paint covers better and barely disturbs the previous layer of paint. In any case, the brush should always be charged with a lot of paint. To keep the color from becoming muddy, the paint should be on the tip of the brush and the brushstroke applied firmly and evenly.

In alla prima *painting, we progress without going back over what we already painted.* Each brushstroke contributes a new variant of color.

Painting with the tip of the brush drags the wet paint that is underneath.

Press repeatedly so that the top color blends with the bottom color.

The bristles are full of thick paint, and the paint is applied with the brush at an almost flat angle to keep the two colors from mixing.

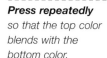

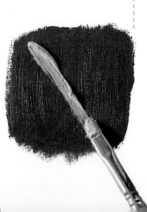

Texture with the Brush and Palette Knife

When working with thick, heavy layers of oils, each placement of paint on the surface retains the imprint of the brush or the palette knife. Most artists take advantage of the character and texture of these

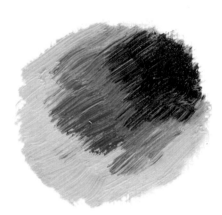

When applying the thick paint over a wet layer of paint, the brush should be fully charged with paint so the mix looks good.

With a flat brush and diluted paint, you can practice a striated brush stroke, formed by multiple lines.

With a palette knife or flat brush, apply colors using short brushstrokes until you have achieved very structured juxtaposed applications.

Gradating is most effective if it is done with thick paint; in such a case it is more effective if it is not as smooth.

strokes to achieve a finished piece that is very expressive. Textures made by the brushstrokes create paintings with groupings of rhythmic lines, giving an extraordinary feeling of movement to the subject.

A striated application made by dragging a palette knife creates an accumulation of various colors on the surface.

To create a scale-like surface, use the palette knife to repeatedly tap the fresh paint until you get a fragmented texture.

Accumulated brushstrokes of different colors, some overlapping others, create a very textured effect. It will be even more effective if you vary the direction of the brushstrokes.

Swirling the thick paint to form circles with the brushstroke is an excellent way to make an energetic texture, very useful in representing vegetation.

THE SUBJECT

Fluidity and Expressiveness of the Line

The fluidity and expressiveness of the brushstroke are also important. Therefore, a good outdoor sketch begins with lines, applied with ease and agility, that capture both the internal rhythm of the subject and the feelings of the artist rendering it. In this section, you will discover some ways to achieve greater fluidity in your drawings.

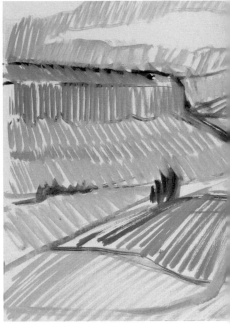

Using a medium or wide flat hog hair brush, define the shapes of the subject.

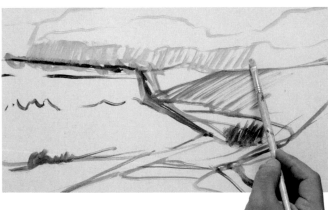

Apply the color on the canvas making sweeping movements with your arm; do not worry about going outside the lines of the shapes you have already created.

Helpful Varnish

To do the exercise that is shown here, you will need to have a jar of Dutch varnish or cobalt drier on hand. Both substances can be used to thin oil paint, so that long, effective brushstrokes are possible. The difference between the two solutions is that cobalt drier also substantially reduces the paint's drying time

Diluted Paint

The same exercise can be done with oils diluted with turpentine and watercolor paint. With this medium, the brushstrokes can even form puddles or drips that create greater abstraction of the subject.

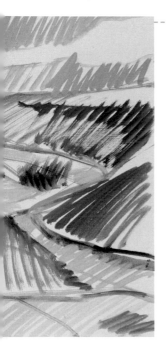

Brushstrokes should go in a clear and visible direction. You don't have to make a painting that is exactly like the subject; simply recreate the feeling by allowing the power of the brushstroke to dominate the color.

It is not a good idea to use small formats. Better to use a large sheet and give free reign to the movements of the arm, which should always be straight and firm.

Cobalt drier can be used to thin the paint and to accelerate the drying process.

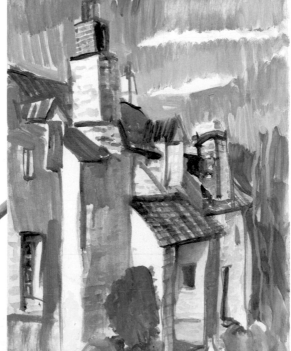

A Seascape with Expressive Brushstrokes

This seascape shows a rugged coast with rocks and a rough sea.

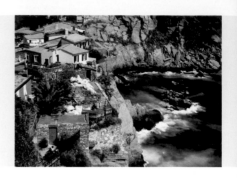

1. The initial sketch can be done in pencil. Afterward, you can go back over it with a blue wax crayon. You must press firmly so the outline of the shapes is visible.

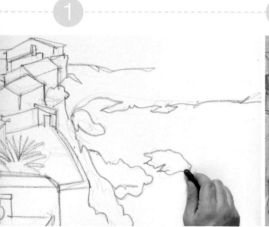

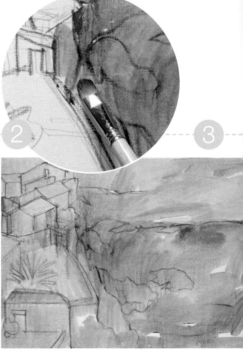

2. When the oil stick comes in contact with the turpentine, it will dilute slightly and its pigment will mix with the thinned paint from the first application.

3. The main areas of the picture are covered with diluted blue and orange paint: the ocean with orange, and the coast with blue. The background is prepared with complementary colors that will strongly contrast with the real color that will cover each area.

Oil paint has a naturally thick and creamy consistency that allows you to apply heavy brushstrokes on the surface of the picture to create the effect of movement or to give more expressiveness to the composition.

Here, the brush saturated with paint moves in various directions to provide striking textures to the rocks and on the surface of the water. Flat brushes or filberts are the most suitable for working in this style because they hold a lot of paint.

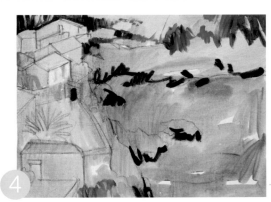

4. You barely have to wait a few minutes for the first layer of paint to dry before painting with more opaque oils: some dark brushstrokes at the base of the rocks and other greener ones for vegetation.

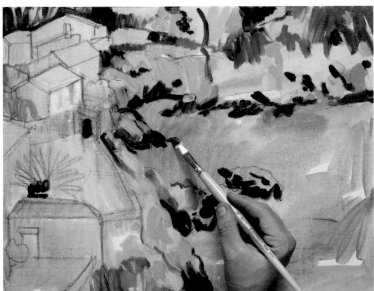

5. Use grays and violets to mark the dividing line between the cliffs and the water. New brushstrokes with whitened ocher and some greens will follow in a disorderly fashion over the rocks.

7. Apply paint generously over the water. The greasy surface of the oil makes each brushstroke clearly delineated, giving the sea its agitated quality.

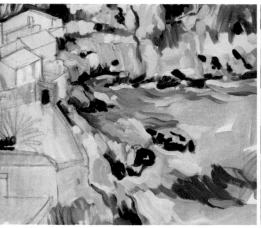

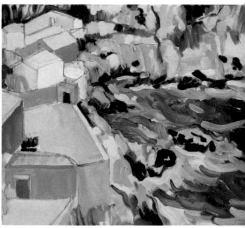

6. Using different blues—ultramarine, cyan, and cobalt—mixed with a little bit of white, apply the first brushstrokes over the water. All parts should show marks and should follow the direction of the surface: vertical on the rocks and horizontal on the water.

8. In contrast to the technique for the seascape, the walls of the houses are painted with flat homogenous colors. The treatment is very artificial, it does not pay attention to the anecdotal. This contrast makes brushstrokes on the rocks and the water even more effective.

EXPRESSIVE BRUSHSTROKES

9. Numerous brushstrokes of distinct ocher and raw sienna tones accumulate on the rocks, all of them going in the same direction. They blend, in some cases, with the greens of the vegetation by dragging part of the color beneath.

10. The final result is dynamic and pleasing. The grouping of houses with clean, illuminated facades strongly contrasts with the fury and harshness of nature, which is represented by agitated brushstrokes with a clear expressive intention.

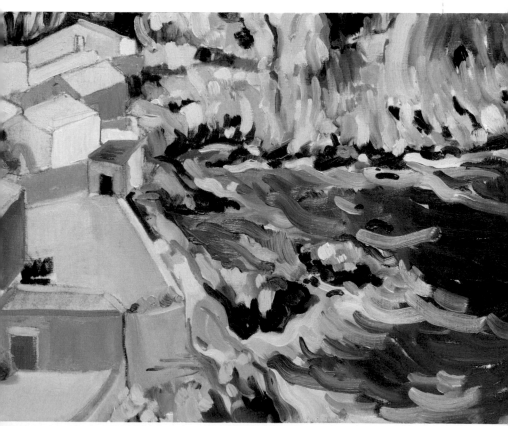

Diluting Paint

One of the techniques that both watercolor and oil painting have in common is diluting paint until it has the consistency of water. Diluted paint has multiple applications: it is used for staining, for working with glazes, and for giving a finished piece a more luminous appearance.

Very diluted paint allows you to mix colors directly on the support, making gradations possible and facilitating smooth transitions from one color to the next.

When applying diluted paint to a tilted support, drips can result. These should not be viewed as errors but as happy accidents that can be incorporated into the final product.

Diluting oil paint with Dutch varnish creates a fluid and very transparent color.

If the diluted paint is applied over a surface with textured gesso or another substance, the pigment pools in the grooves and creates a relief effect.

If you first wet the support with a light coat of varnish, the color will spread more fluidly and the outline of the brushstrokes will fade.

When a thin layer of diluted paint is wet, you can create white spaces simply by wiping a dry cloth over it.

Glazes have multiple uses. They are usually applied to superimpose layers of different colors in order to create deeper colors.

When dampened with turpentine, the line or brushstroke fades too much and nearly vanishes.

Paul Cézanne
(1839–1906)

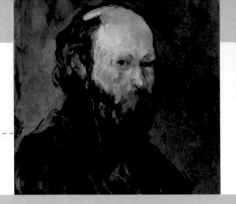

Impressionist painter, considered one of the precursors of twentieth-century contemporary painting.

THE LUMINOSITY OF THE LANDSCAPE

Provençal Landscape *(circa 1880)*
For Cézanne, watercolor complemented the affinity he expressed for color and light, and he was very attached to it because of its transparency. His own particular method did not have excessive mixing of the washes on the paper, and allowed one color to dry before applying the next. This gave great luminosity to his landscapes, because one color shines through the other. His style was also characterized by the use of a limited range of colors, predominantly blues, greens, and ochers.

1. Here we show the process that Cézanne used in his watercolors. He started his paintings with very light pencil sketches, synthesizing the elements with circular shapes and lines. The first marks are made in blue to strengthen and solidify the picture.

2. The washes of permanent sap green are applied once the initial blue has dried. You must wait for each layer of color to dry before applying the next.

3. Cover all of the paper with very diluted ocher-colored wash. After it dries, apply a new diluted wash, this time in raw sienna. Using a medium green and a thick brush, indicate the lower parts of the trees.

4. Again using ocher and raw sienna, intensify the sky, the mountain in the background, and the river. Use Payne's gray to highlight the tree trunks. Add some final transparent blue brushstrokes when the whole painting is dry and finished.

Cézanne was one of the painters who most valued outdoor painting, and he paved the way from Impressionism toward abstraction. He was interested in reconstructing nature using structured strokes of color, with the correct placement of graduated colors, but without simply reproducing what he saw. Unlike the other Impressionists, he did not attempt to recreate the reflections of light from the surfaces of objects, but rather he strove to paint the light itself as it appears in colors.

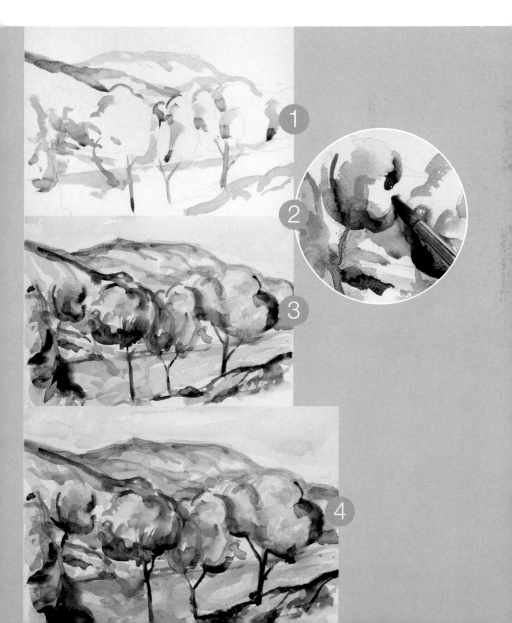

Using Glazes

Glazing is one of the traditional techniques associated with watercolor painting. Glazing consists of covering one color with another very diluted color, forming a translucent veil that alters the color underneath. Although it is not a technique commonly used with oils, it is not unheard of. Note that if you intend to use this technique outdoors, it is important to use additives that accelerate the drying process.

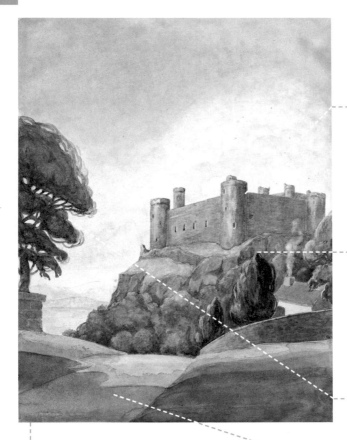

Burnt umber and ultramarine blue *on the castle.*

Phthalo green and burnt sienna *for the vegetation.*

Prussian blue and raw sienna *on the tree.*

*A thin glaze applied over a dry color **softens the contrasts** and creates deeper colors. Notice the remarkable overlaid colors used in this watercolor.*

Prussian blue and ocher *in the shade of the road.*

Deep Colors

Watercolor glazes possess an intensity that is impossible to obtain by physically mixing the colors on a palette, since the transparency transmits and reflects the light of the paper on which they are painted. Each successive glaze modifies the color under it, but does not obscure it completely. Glazes are favored by outdoor painters because the colors dry quickly. The medium needs only a few seconds in full sunlight for each diluted color to dry.

Use Turpentine Sparingly

When painting glazes with oils, you can begin the work with one initial layer of turpentine-diluted paint, but the next few layers should be diluted with varnish or dryer; the latter mediums keep colors cleaner and pure. If you were to continue with turpentine, the colors might crack, show splotchy pigment, or even worse, turn gray. A special medium that accelerates the drying of the paint is also recommended. Many artists use cobalt drier, but any type of matte varnish can be used.

The addition of one layer of glaze over another should be applied when the first layer is completely dry. The more layers, the darker the color will be.

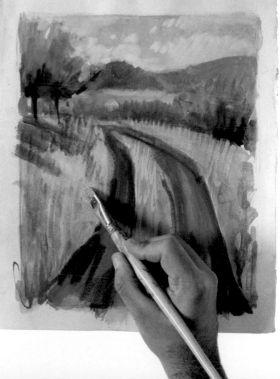

Choose a hot day to paint a landscape with oil glazes, since warmer temperatures accelerate drying. If the weather doesn't cooperate, the next best thing to do is have your first session one day and finish two or three days later.

Working with Palette Knives

Painting with a palette knife can be more complicated than using a brush; it requires constant practice to master it with the necessary ease. Palette knives used for painting are generally associated with thick oil impastos, but they can also deliever delicate and detailed effects. They are most commonly used for small-format landscapes painted outside.

The effects created with a palette knife include modeling by dragging paint and sgraffiti made with the rounded tip, as seen on the façade of the building.

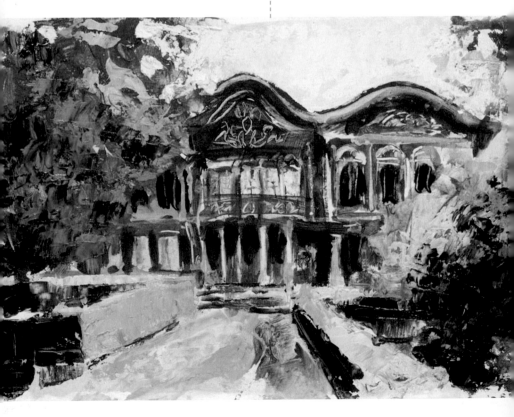

Applying Paint with a Palette Knife

The primary job of the palette knife is to control the spread of paint. One or more colors from the palette are picked up with the bottom of the flat blade. Then the paint is applied on the canvas, by pressing lightly and slightly raising the edge of the blade. Apply less pressure if you want a thicker layer of paint, and more if you wish to spread the paint in a very thin layer. The marks made by the palette knife can go in different directions to make the colors form more interesting shapes.

Advantages of Painting Outdoors

Painting outdoors with a palette knife is convenient and has some bonuses. For one thing, this technique does not require the use of turpentine; all you need is a small piece of paper to clean the palette knife each time you want to change the color. Other advantages: each mark of the palette knife creates an attractive relief, the colors mix right on the canvas forming striations, and details and retouching are not possible. This last point is especially advantageous when you want to create a fresh and spontaneous impression of a natural subject.

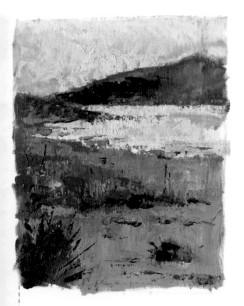

Using the edge of the palette knife, drag the color and mix it on the surface of the canvas.

The rounded tip can be used as if it were a brush, making light impressions that create short lines pointing in the same direction.

Impasto loses its freshness when the colors blend too much. It is most effective when the paint is gathered on the palette knife and deposited by lightly dragging it across the surface of the canvas.

Pressing down with a flat palette knife, the paint scarcely shows relief and the colors are more easily blended.

Interpretation and Weather

Learn to appreciate all the color possibilities your subject has to offer. There is always great potential for personal interpretation and creativity on the part of the artist, who is free to modify the palette to his convenience. The climatic elements of a landscape have a major influence on the sky; they influence a painting's atmospheric quality and chromatic harmony, and they can brighten or blur an outline. Learning to identify and give form to meteorological factors is essential when recreating a realistic and accurate interpretation of a landscape. In the pages that follow, you will further reflect on color, but now with special attention to how it serves to reflect an artist's personal creativity and also how it can be used to interpret specific weather conditions.

Harmonic Range of Colors

Personal taste in color combinations is critical in painting any scene, but you must be aware of some options before starting and keep certain rules of harmonization in mind. The tones of one color family relate to each other in a way that creates a natural harmony—one in which color can unify the shape and structure of a composition.

One way of harmonizing a painting is to start with an analogous chromatic sketch that uses colors adjacent to each other on the color wheel. In this case, we worked with yellow, ocher, red, orange, and warm greens.

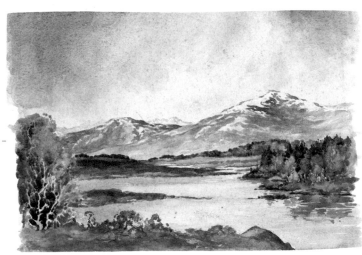

Here the dominant color is gray-brown. To achieve harmony, simply mix one of these two colors with the other colors that will be in the painting.

Chromatic Unity

The color and atmosphere of a landscape are a factor of unity. This means that all the colors of the landscape should be related so that they interact and show harmony. Therefore, do not paint each area of a painting as if it were a closed space, independent from the rest of the subject. Instead, unify the chromatic ranges so that neighboring colors affect the entire surface of the piece.

Chromatic Accord

To ensure chromatic accord you must begin with one dominant color and create links between that color and the others. For example, you can achieve a harmonic range of greens by mixing different kinds of green with yellow, orange, blue, violet, ocher, and so on. This way the colors support and accommodate each other, creating a representation that is neither jarring nor boring. This concept is known as chromatic accord, which, as in music, contains many notes but produces only one sound, a single harmony.

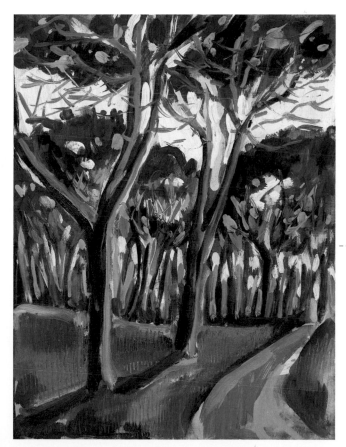

When the range of colors is very limited, as with these blues and their adjacent colors (green-blue, violet), the painting is always very harmonious and has no startling or uncontrolled contrasts.

Color and Depth

Excessive uniformity or a totally monochromatic scheme can result in a boring painting. On the other hand, discordances and contrasts make a composition more interesting and help to organize the space and distinguish between areas that are closer and farther away. The play and progression of these contrasts act like screens that help illustrate the depth of the landscape.

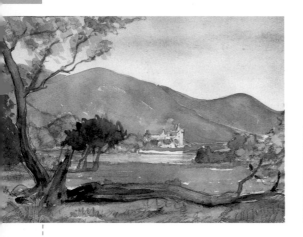

A row of trees in a landscape, because of their height, gives the viewer a standard perspective. They create the feeling of depth.

Any element located in the foreground, such as a fallen tree, contributes to the depth of the landscape.

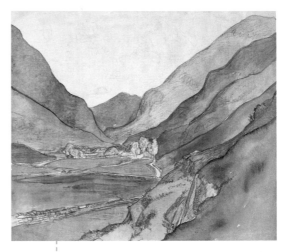

A landscape can be understood as a succession of planes, acting like backdrops. Each one of them has a different color.

Each stripe in this valley has been treated individually, with distinct colors that show distance.

Near and Far

In the foreground, the silhouettes and outlines of each element are defined by the contrast between tone and color: light versus dark if we are talking about tones, and warm versus cool if we are referring to color. The linear brushstrokes are redundant because the edges look like cutouts against areas of different tones. As for the colors, even though the same light covers the whole landscape, the closest elements have more saturated, contrasted, and usually warmer colors. The farther planes are lighter.

To emphasize the perception of depth, distribute the colors in an orderly manner: ranges of warm colors in the first foreground, neutrals (grays and browns) in the middle plane, and blues in the background areas.

How to Handle a Lush Landscape

When you paint densely wooded areas, groups of rocks, a succession of mountains or strips of land, they should be translated into color screens that allow you to define planes more easily, as well as show the effect of fading distant color. Here is how to do it: first divide the landscape into various chromatic screens, then plan the colors that you are going to use, remembering that the lighter or bluer colors will work best with the more distant planes in the landscape. To finish, overlap the screens with each other using the principal of simultaneous contrast, in which the darker parts of screens are superimposed on the lighter ones, and vice versa.

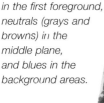

Creating Atmosphere

Painting the atmosphere means giving greater relevance to the air between you and your subject, as if it were denser and foggier, forming a veil that softens the shapes of the landscape. Understanding this concept and applying it to the farthest areas is important in highlighting the depth of a landscape.

Spraying creates deposits *of thousands of tiny points of color over the surface, partially covering the layer of color underneath.*

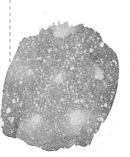

The mountains in the background *begin to fade because of the intervening atmosphere.*

Spray applied over a blurred landscape *aims to represent the multitude of dust particles or droplets of water that are in the atmosphere.*

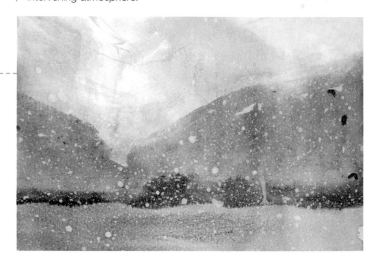

Can You Paint Air?

The invisibility of air can lead us to think that this is impossible; nevertheless, on some occasions, the atmosphere is visible in the form of mist or air vapor that bleaches and creates more blues in the farthest areas of the landscape. Therefore, when a great quantity of air or atmosphere is in front of the subject, it is recreated using glaze or by adding a multitude of tiny points or drops to the surface to simulate the dust particles in the air.

Using Spray

When attempting to reproduce specks of dust or small drops of water that float in the air, the technique of spraying is a good option. Charge a hog bristle brush or a toothbrush with a diluted color (watercolor, acrylic, or oil), and scratch the bristles with your fingernail. This will cause a spray of droplets over the surface of the painting, forming a glaze of small dots of color that give the impression that the air has become denser.

Fog is another way to show atmosphere. With oils, the effect of fog is created by applying light glazes of paint diluted with Dutch varnish. If you blend the tonalities and associate chromatic tones instead of contrasting ones, the scene acquires an atmospheric feel, as if a fog is uniting all the elements.

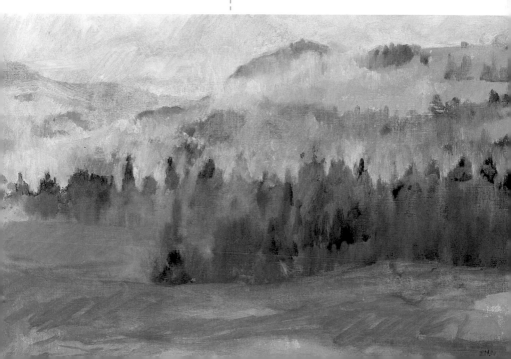

Outside in Broad Daylight

Shadows are a product of light and are inherent in any sunny landscape. Since light, understood as an element or material, cannot be painted, the only way to represent a scene that is strongly illuminated with sunlight is to represent its by-product, in a very contrasted form, which is shadow.

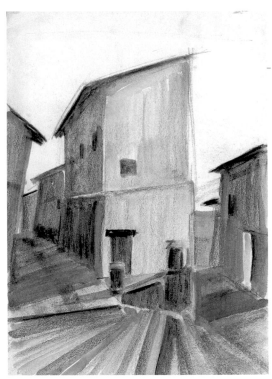

The sunlight bathes *the illuminated areas with warmer tones and induces the appearance of blues and violets in the shadows.*

The intensity and color of shadows vary *throughout the day, depending on how brightly the sun is shining. The stronger the contrast of the shadow, the brighter the light appears.*

Intense Sunlight

How do you paint a landscape that is intensely illuminated with sunlight? The secret lies not in the light, but in the shadows. You can create the impression of light by showing signs of the contrast with shadows. On sunny days, the illuminated areas have a yellowish or orange chromatic tendency, and the shadows appear dark with sharp edges. The boundaries between the light and shadows are very defined and cut with total precision.

Shadow and Reality

Shading does not have to be realistic. Shadows, just like the points of light, can be conveniently manipulated, to accentuate an outline or to create dynamic effects in the painting. Shadows can alter or modify the viewer's perception and cannot be understood in isolation; they have more impact when viewed as a whole.

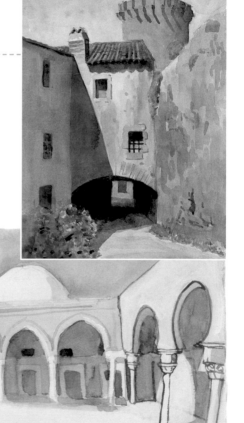

*The presence of shadows is **important** in this representation of a scene bathed in intense sunlight. It is the only element that indicates the intensity and angle of the source of light.*

*On this patio, there is a feeling of **strong sunlight**. This effect is achieved with very marked contrasts.*

Rainy Landscape

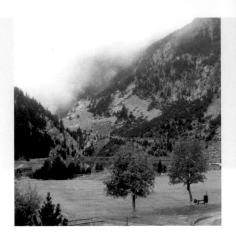

A rainy valley on a high mountain, with grayish colors and lacking the strong contrasts that come from sunlight.

① ②

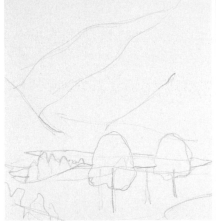

1. *Draw with a graphite pencil instead of charcoal; this way, you avoid the charcoal dust that could darken the soft white contributions of the background. It is most important to outline the mountains and the two trees close to the front.*

2. *When you paint a landscape and you want to create a feeling of depth, it is best to begin with the sky and the farthest figures. Using a little blue mixed with a lot of white, cover the top part of the canvas; then add a greater proportion of blue as you move downwards.*

The color choice for a natural landscape under intense rain is much different than that of a sunny scene. Rainy days require grayer colors in the landscape, since the direct light of the sun (the principal source of color) is mitigated by the heavy storm clouds. The effect of rain is achieved by blurring outlines and by using a short, vertical brushstroke, like the curtains of water that distort the forms of the landscape.

4. On the side of the mountain, alternate areas of vegetation with those of grass, which are made with ocher and green marks. There are no outlines and the forms of the trees are barely distinguishable—only a road that crosses the scene is visible.

3. The farthest mountain is barely distinguished from the color of the sky, but a new hillside is constructed by adding a greater proportion of raw sienna, blue, and permanent sap green to white. The painting should be dense so that the colors blend smoothly. Avoid diluting it with turpentine.

5. The vegetation is represented with vertical brushstrokes, juxtaposing distinct green marks that present a smooth transition from one tone to another. The painting advances from the background to the foreground.

LET'S EXPERIMENT

7. *With the background finalized (perhaps the most complicated part because of the diverse colors and different surfaces), the grass in the foreground is painted with cadmium and cinnabar green.*

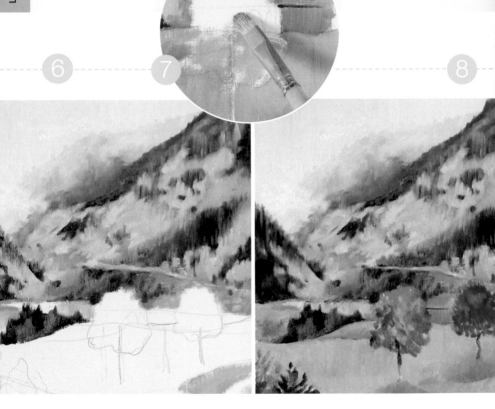

6. *The lake is represented by a graduation of white to gray paint with no brush marks. The vegetation closer to the foreground incorporates warmer colors such as cinnabar green or yellow ocher. The proportion of white in the mix decreases with each layer toward the foreground.*

8. *Finally, the trees are painted with a mixture of ocher, burnt umber, raw sienna, and cadmium red. Remember to add a bit of white in each mix. The trunk is light gray in the lower part and darker closer to the top.*

9. There is still one last step. Using a dry brush, make short vertical brushstrokes to blend the colors and emphasize the effect of the falling rain. Falling rain is not always actually visible, but the artist should learn to interpret it with similar effects or graphics.

10. The atmosphere is teeming with water and fittingly the vertical brushstroke used will allow only a blurred image of the landscape. Under an intense rain, the whole scene would disappear.

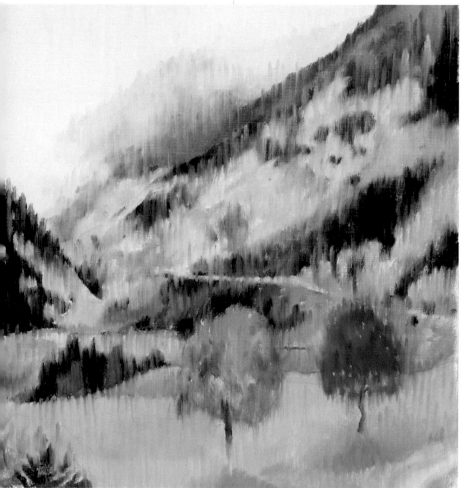

Additions and Graphic Effects

The artist should help himself to the many graphic possibilities that are within his reach to appropriately express the texture of the elements that make up his subject. We are not referring to a specific way of painting, but rather a way of manipulating the paint once it has been applied. These methods serve to add the small details that give finished watercolor or oil painting its definitive character.

If you sketched with oil pastels, you can dissolve the marks with a little bit of turpentine and incorporate the line in the painting.

A similar effect is produced in lines made with dry pastels if they are painted over with watercolors.

A water-soluble pencil or stick simultaneously shows the presence of the line and the wash.

In a still wet wash, you can create graphic effects with the end of a brush handle to suggest the shapes of branches or the trunk of a distant tree.

If you apply pressure on wet paint with a crumpled paper towel, you can give a textured appearance to the wash.

When a surface has a thick layer of paint it can become textured by repeatedly scraping it with the edge of a palette knife blade.

You can add impastos with a small pallet knife over uniform washes. This is most effective when some areas are left uncovered.

An erased effect is achieved with the edge of a metal palette.

In watercolor, a sgraffito effect can be created with the point of a craft knife over a wet wash.

Urban Scene: Contributions

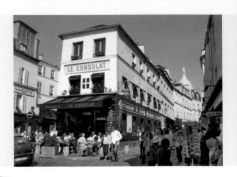

The subject is a classic with artists: a narrow street in the picturesque neighborhood of Montmartre, Paris.

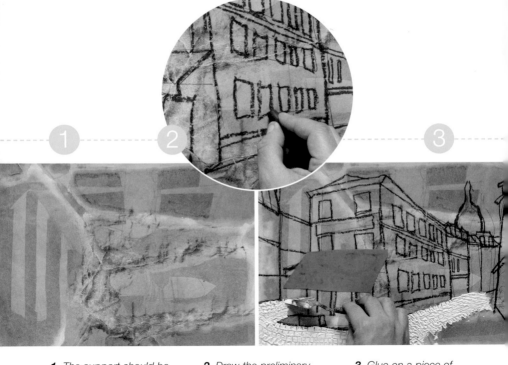

1. The support should be prepared days ahead, with a collage of torn papers affixed with white glue or latex. Ocher and gray are the most appropriate colors for painting this background; neutral colors adapt well to all kinds of subjects.

2. Draw the preliminary sketch with pencil. Consider the principal lines of perspective that define the street so the space looks coherent. Some lines are darkened with a red wax crayon.

3. Glue on a piece of orange poster board to represent the café awning. Use gesso to simulate the texture of the cobblestone in the street, forming the paving stones with the rounded tip of the palette. Leave the picture in the sun so the gesso can dry.

In this exercise, we will put into practice some of the methods described in the previous pages. To begin, we'll use a support that was previously prepared at home. Textural effects will be created with gesso. The sketch of the buildings is created using apparent perspective, with a certain amount of distortion to make it more expressive. Oil paint is the medium.

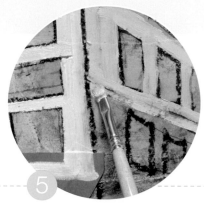

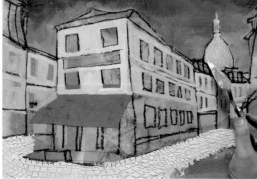

4. *After twenty minutes, take up the support again. It does not matter if the gesso has not completely dried, since you will begin working on the sky, creating a graduation of color with ultramarine and cyan blue.*

5. *Paint the façades of the buildings with thick, opaque oil, reserving spaces for the windows. Use light blues, grays, and ocher.*

6. *The same thick paint is used to make the cupola of the church that stands above the roofs. Then add sgraffito with the rounded point of a palette to suggest tiles.*

7. *The lower parts of the façades are defined with more intense and darker colors. Use saturated colors, since the objective is to create a colorful and attractive painting. The wax lines of the sketch are not completely eliminated; they provided yet another attractive visual element.*

8. *Using diluted raw sienna, paint the gesso texture, which is now completely dry. The openings of the doorways and windows are next filled with intense blue and black. Apply uniform brushstrokes, without focusing on detail.*

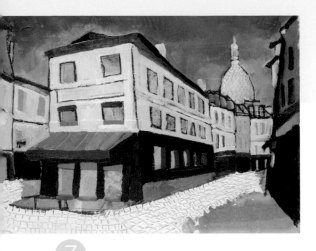

7

8

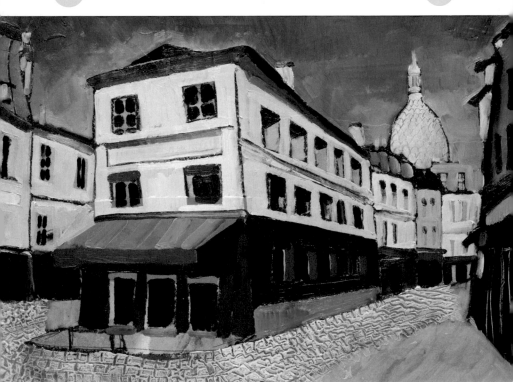

9. Paint the figures with diluted blue paint. When painting groups of figures make sure that they are well situated in the pictorial space. The figures are little more than brushstrokes, but they are recognizable as people. Their size in relation to their surroundings provides an indicator of scale.

10. Finalize the details of the façades, the transoms, the streetlights, the signs, and the chimneys on the roofs. Give the final touches to the people, alternating lively colors. Including figures in an urban scene introduces a narrative element and gives life to the picture.

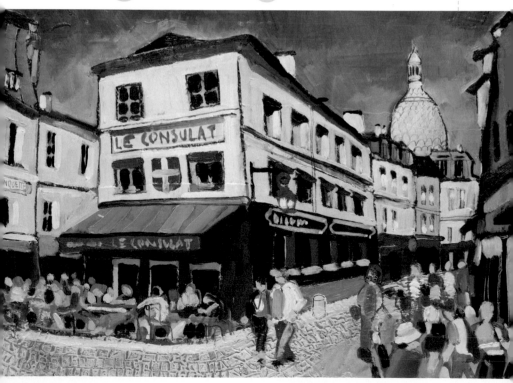

Focusing on the Sky

The sky is a passing and changing subject, which is difficult to capture on canvas or paper. It is usually the first part of a landscape to be addressed since it determines the general feeling of the scene and it impacts the important tones of light. In other words, the sky is the source of light and therefore its presence affects the colors in the work. This is why it must be treated as an integral part of the composition.

Clouds are usually represented with a more rounded and voluptuous shape the higher they are, and with a flatter and more elongated base when they are lower and closer to the horizon.

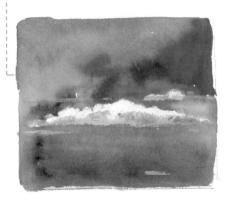

A clear sky is rarely painted as a uniform body, but rather as a gradation between different tones of blue.

The blue of the sky determines the color of the water and the atmosphere of any scene.

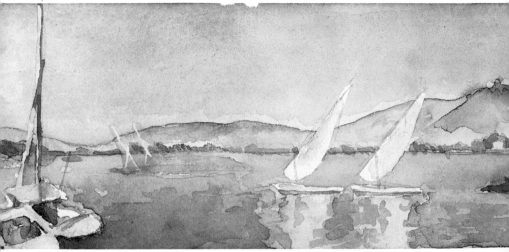

Clear Skies

The laws of perspective are applied to the sky in the same way they are applied to the ground. Therefore, abandon the idea of painting the sky with a solid blue. Because of the effects of atmospheric perspective, the sky appears warmer and brighter on the upper areas, while becoming progressively cooler and lighter as it gets closer to the horizon. So even painting a sky without clouds requires gradations, because its color changes as it approaches the horizon line.

Dusk

The light at sunset presents a rich range of colors, from bright yellow, orange, and turquoise tones to deep violets and blues. The landscape darkens and becomes immersed in blues and violets. The only drawback when painting from nature is that the light and the colors reflected on the clouds change in a matter of minutes. That is why the artist must either paint fast or make a sketch of the effects to help him finish the painting back in his studio.

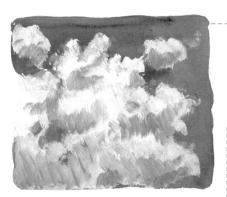

The clouds appear smaller and closer together the farther away they are, and sometimes they blend together in a foggy body on the horizon, turning gray and cool at the same time.

At dusk, the combination of the sun's rays and the cloud masses can create very dramatic effects.

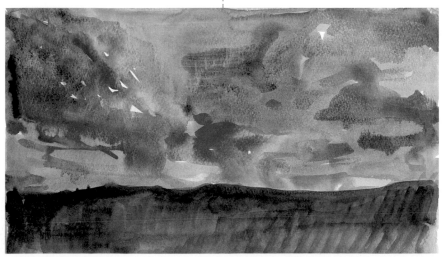

Seasonal Colors

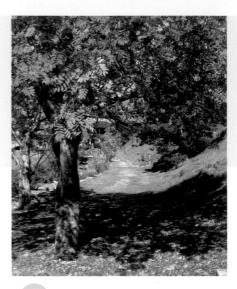

A tree whose colors announce the fall
season has a range of red, orange,
ocher, and yellow tones.

①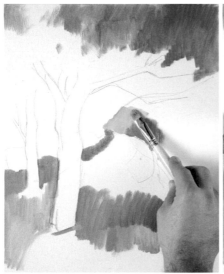

②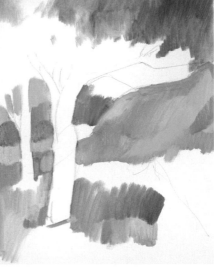

1. The main focus of the pencil sketch is the
shape of the tree trunk without the leaves.
Using oil paint diluted with turpentine, cover
the area of the sky and paint other areas of
the ground with different tones of ocher.

2. Before painting the tree it is important to
have the background more or less finished.
The tree trunks are left unpainted.
3. The shaded areas are painted with a range
of violet tones, making it possible to use more
saturated colors for the leaves.

Each landscape has its characteristic look, determined by the interaction of colors, the atmosphere, and the light that falls on it. All these factors in turn are affected by the weather conditions and the typical colors of the season being represented, especially if the theme is a deciduous forest or a mountain scene. Often, it is possible to convey the character of the season, in this case an autumn scene, through saturated colors and by exaggerating some effects and brushstrokes.

5. *The treetops are the result of a patient accumulation of brushstrokes, painted tightly together. These brushstrokes are not random but rather applied in a deliberate way. A few touches of light green tones are added to lighten up the ground.*

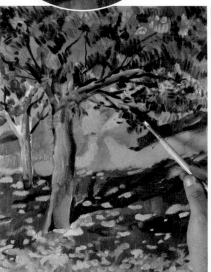

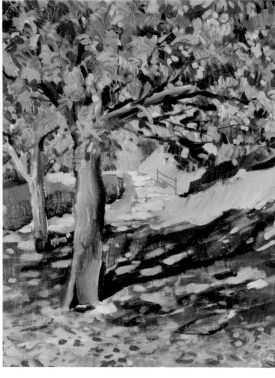

4. *Dry leaves are painted over the dark ground with yellow and ocher mixed with white. The thinner branches and the shadows on the treetop are painted with burnt umber. Next, a few small touches of orange, yellow, and red are added.*

Depicting the Weather

Much of the pleasure and emotion evoked by a landscape painting comes from the observation and understanding of the changing effects of weather. The transformation of nature offers new colors and new feelings requiring a different interpretation for each situation. The artist's medium must suggest graphically or symbolically the effects produced by adverse weather conditions, whether through graphic devices or through the use of specific colors.

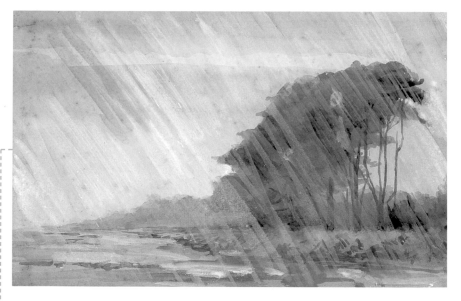

Rainy days are gray and colors lose their saturation and intensity. Rainfall can be painted with transparent white brushstrokes.

A heavy rainfall can turn a peaceful landscape into a dramatic scene. A heavy curtain of rain can blur out the forms of the vegetation, rendering them almost invisible.

Ways to Represent the Rain

A heavy rainfall can be depicted by making diagonal lines with the brush over heavy oil paint, or by applying sgraffito with a craft knife over watercolors when they are still wet. It can also be painted as if the landscape were immersed in fog or mist, which can be conveyed by subtle effects that are almost imperceptible: dark colors and diffused forms that require careful attention. Rain can be accompanied by heavy fog that blurs the view of the most distant objects of the landscape.

Snowy Landscapes

Snow reflects light and divides the land with strong contrasts of light and shadow. Be careful; snow is not always white. When painting a snowy landscape it is important to avoid drenching it with white. Shady areas covered with snow tend to have blue and violet tones. The color of the most illuminated areas can also change at sunrise and sunset, a time when light can tint the snow with pink and orange tones.

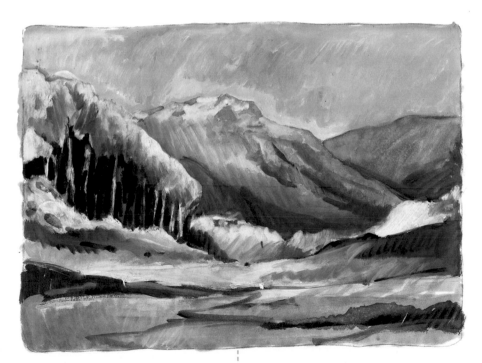

Snow acquires blue and violet tones during the first hours of the morning when the sunlight is not yet very strong.

How to Paint Clouds

To paint a cloud, first you must paint the blue sky around the mass of clouds. Then, simply add a shadow of violet color on the underside of the cloud.

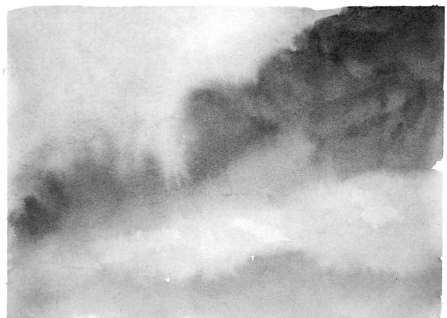

The fluidity of watercolors makes it easy to paint clouds with blurry edges that blend with the blue sky. To achieve this effect, the paper can be dampened beforehand.

Clouds should be treated as if they were abstract forms. This exercise will help you understand how to paint them with the right combination of forms and colors. Careful attention must be given to their edges so that they blend naturally with the surrounding atmosphere.

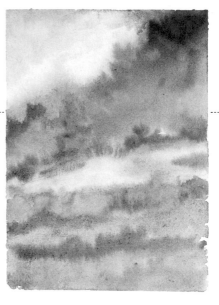

When painting a cloudy sky with oil paint, the direction of the brushstroke is as important as how the various colors blend.

On wet paper the blue of the sky is painted bordering the edges of the clouds. A few gray brushstrokes are enough to represent the shadows. Then, simply wait a few minutes for the color to spread and blend.

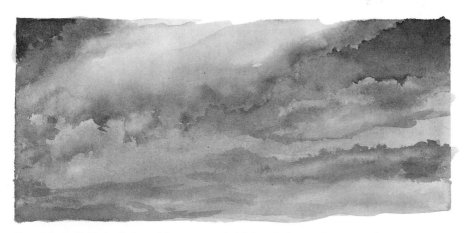

To paint a twilight sky, first use blue, gray, and violet, as in the previous examples. Then, when the paper is dry, a very transparent yellow and orange glaze is added.

Charles-Marie Dulac (1865–1898)

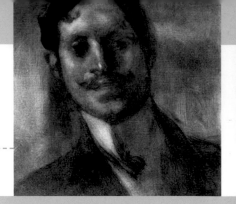

Like all symbolic artists, Dulac painted very spiritual renditions of landscapes.

THE SOUL OF NATURE

Forest Landscape, *1896.*
This painting shows the lonely paths of a silent forest. They have been painted with deliberate brushstrokes that cover the ground with orange tones, and the tree trunks have blue-grays applied so tightly that they block the view of the end of the forest. The sky is hardly visible; the diagonal and rounded lines of the tree trunks that border the path are the elements that provide the structure and continuity to the painting.

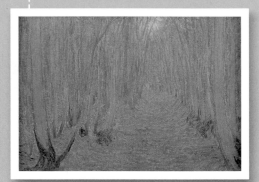

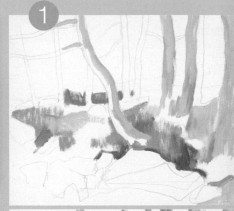

1. First, a very simple sketch is drawn and the first brown and green colors are applied. They should have gray and white underlying tones to set the specific color scheme.

2. Using a thin brush, paint the green spaces between the trees in the background, which were previously left unpainted. The brushstrokes of the vegetation are all applied in the same vertical direction.

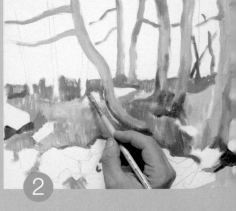

This symbolist painter began his career doing technical drawings of theater sets. His representations of nature are characterized by the extreme simplicity of the themes and compositions. Dulac possessed a very special sensibility for the subtlety of color and toward the atmosphere of the places he portrayed. The sole objective of his work was to understand and express the soul of nature.

3. The tree trunks in the foreground have colors that range from gray to pink. The background of the forest has been painted spontaneously, with the white of the canvas coming through. In contrast, the rocks and some of the tree trunks are outlined with burnt umber or bright gray.

4. Over the initial layer, new colors with orange and red undertones are added to the forest's undergrowth. The goal here is to represent the colors of the fall season using a range of much warmer ocher and earth tones.

"The eye is fascinated by the beauty and qualities of the colors. The spectator has a feeling of satisfaction, of pleasure, like a gourmet who has a tasty morsel in his mouth. Or the eye is titillated, as is one's palate by a highly spiced dish."

Kandinsky.
Concerning the Spiritual in Art (1912)